The Tale of Jacob Swift

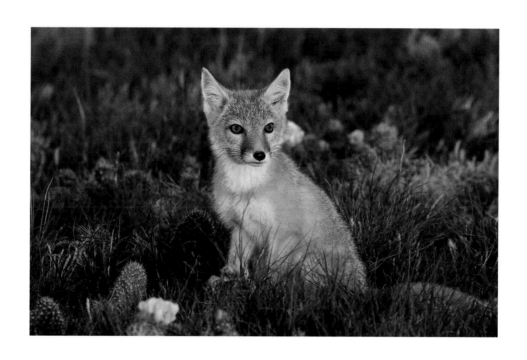

Story by Jeff Kurrus
Photographs by Rob Palmer

For Eli – JK

For my mother – RP

Story © 2014 by Jeff Kurrus

Photographs © 2014 by Rob Palmer

The Tale of Jacob Swift
Story by Jeff Kurrus
Photographs by Rob Palmer
ISBN 978-0-9916389-1-8
Library of Congress Control Number: 2014912784

R.R. Donnelley & Sons Company
Printed in Mexico
September, 2014
1st Printing

Book design by Tim Reigert, Lincoln, Nebraska

Visit www.jeffkurrus.com and www.falconphotos.com.

Foreword

Before you read *The Tale of Jacob Swift*, one question must be asked: What parts of this photo fiction story are real?

Well, many aspects of the story are based on the natural history of the species, including where swift foxes occur. Their populations extend from the grasslands of southern Canada to the high plains of Texas on short- to mixed-grass prairies. Historically, swift fox populations were abundant throughout the Great Plains, but their numbers have declined since the early 1900s for many reasons.

Human influences have had the greatest impact on swift foxes, including the conversion of native prairies for agriculture, overharvest, and historic poisoning programs to remove large carnivores such as wolves, coyotes, mountain lions, and grizzly bears. Because swift foxes are opportunistic feeders, they consumed the poisoned livestock carcasses intended for the large predators, causing unintended mortality. Furthermore, with the removal of wolves from the Great Plains, coyote populations have thrived, becoming the swift fox's main predator.

Swift foxes are the smallest canid, or member of the dog family, found in North America. Adults weigh 4 to 6 pounds, approximately the size of a house cat. Swift foxes also spend more time underground than any other foxes on the continent, including red and gray foxes. They utilize complex, multi-entrance dens throughout their lives for purposes such as raising pups, resting, and avoiding predators. Heavy infestations of fleas and the need for multiple escape routes can lead swift foxes to have many different dens throughout their lives.

As their common name implies, the species is fast and can achieve speeds up to 35 miles per hour over short distances. Swift foxes consume a range of species, including small rodents such as prairie dogs and mice, rabbits, insects, birds, lizards, and berries. They are primarily nocturnal, hunting during dusk and nighttime hours. On warm days swift foxes may be observed sunning near an entrance to their den. The life span of a swift fox is approximately 4 years; coyote predation and vehicle collisions are the primary sources of mortality.

Male and female foxes pair in fall, and breeding occurs from December to February. Mated foxes may remain together for one season or pair for life. Typically, swift foxes are monogamous, with one male and one female mating, and both assist in pup rearing. Occasionally, one male may mate with more than one female. In April-May, an average of 4 to 5 pups are born in an underground den. These pups remain with their parents throughout the summer until they disperse in August or early September. Upon dispersal, swift foxes seek out suitable unoccupied habitat and a mate.

It remains important for readers like you to know the challenges swift foxes historically, and currently, face. Although they were once considered an abundant species, over the past century they have been extirpated from 44% of their historical range in the U.S. I am hopeful that reading about Jacob Swift encourages you to learn more about prairie ecosystems and the unique species that occur within them. Let's work together to ensure that everyone understands the ecological value and importance of the grasslands so species like the swift fox will once again thrive in the Great Plains.

– *Teresa Frink, associate professor, Chadron State College*

When Jacob and his big brother Ethan emerged from their family den for the first time . . .

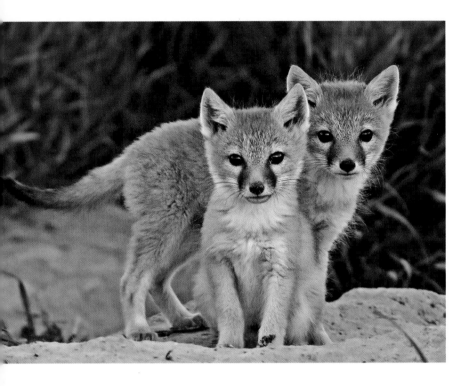

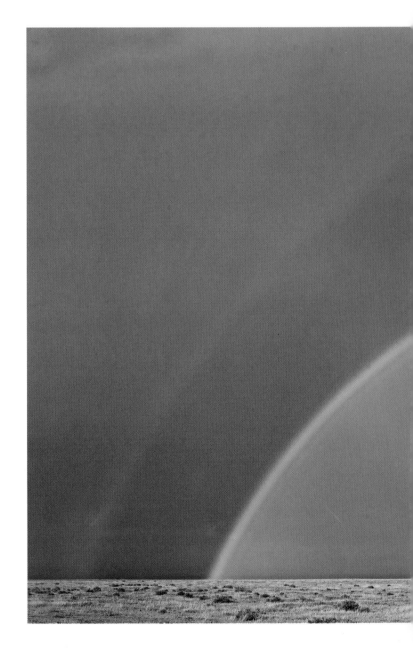

. . . the swift fox pups were greeted by shortgrass prairie in all directions.

"What's that?" asked Jacob, immediately gazing up.

"A rainbow," answered Mom. "Rainbows mean a new life has begun."

"Just like yours today," said Dad. "Your new lives aboveground."

While Ethan tried to take in everything about this new world, Jacob merely turned a quick circle. "Uh, so why do we live here?" he asked. "There's nothing here."

"If you think that, you have not been listening very well during the last month," said Mom.

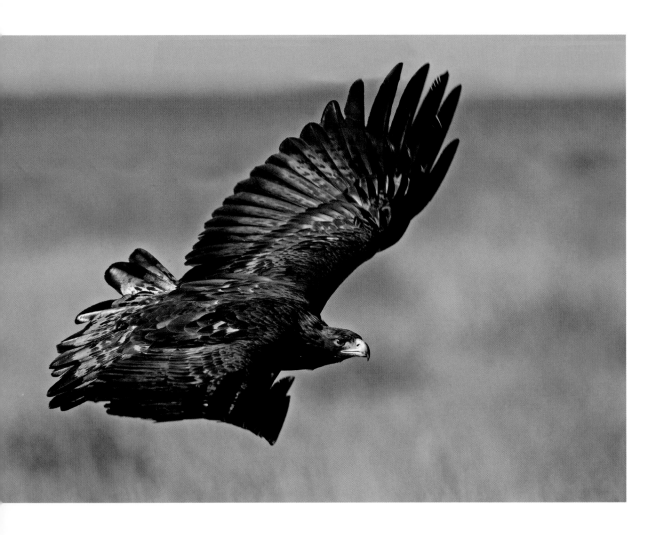

But the brothers thought they had been paying attention. They knew golden eagles weighed twice as much as they did and could dive five times faster . . .

. . . and that coyotes were their most dangerous predator, even during the winter.

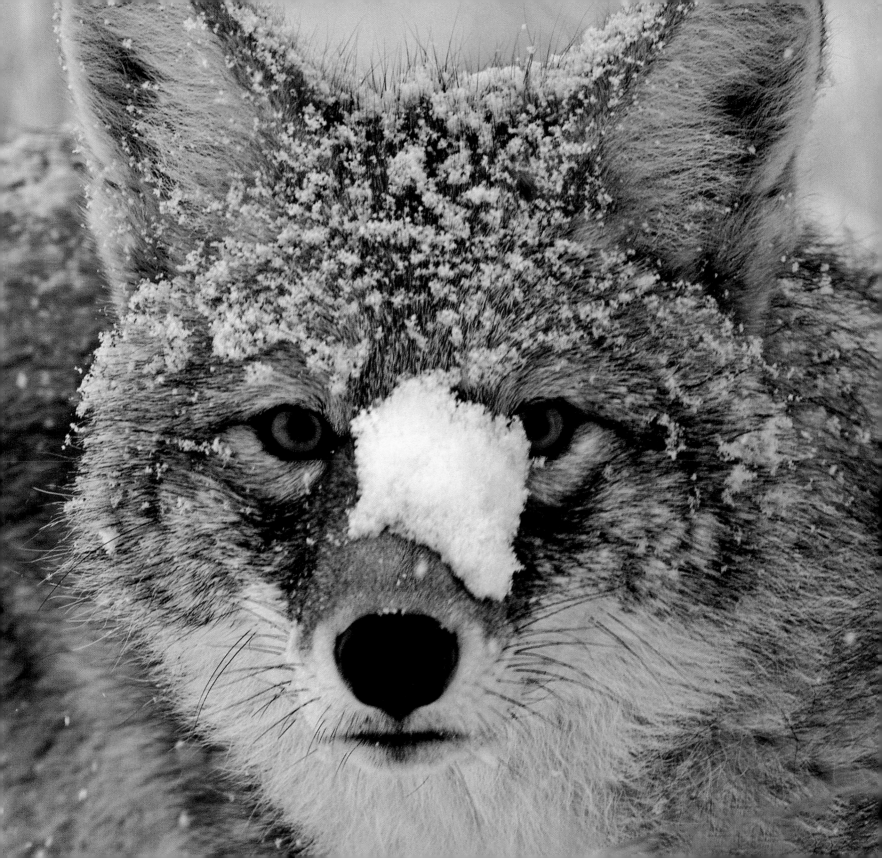

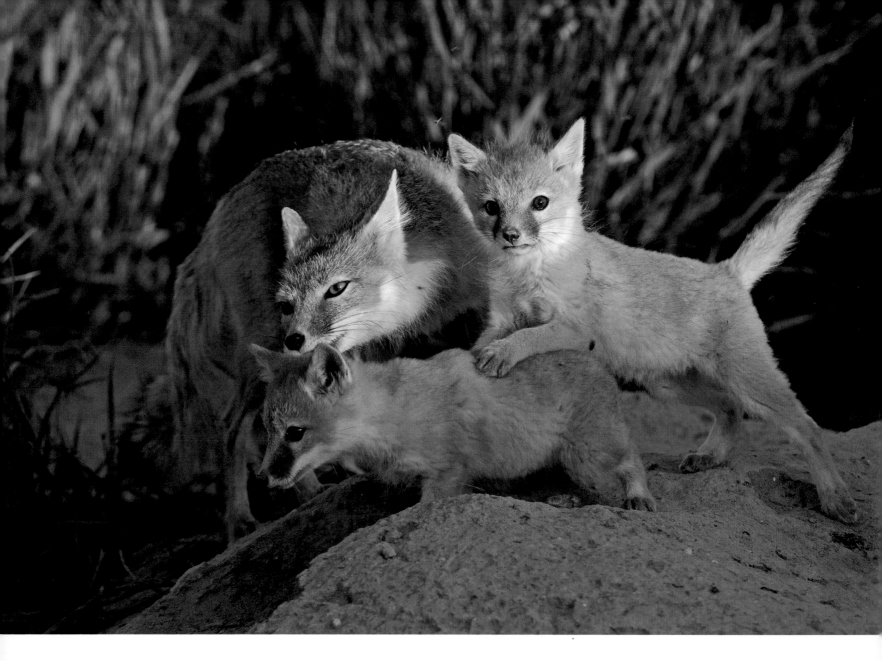

Despite all their underground teachings, though, this new
world still seemed empty to the siblings, so they continued
to play.

Until Mom leaned in. "Look closer, boys."

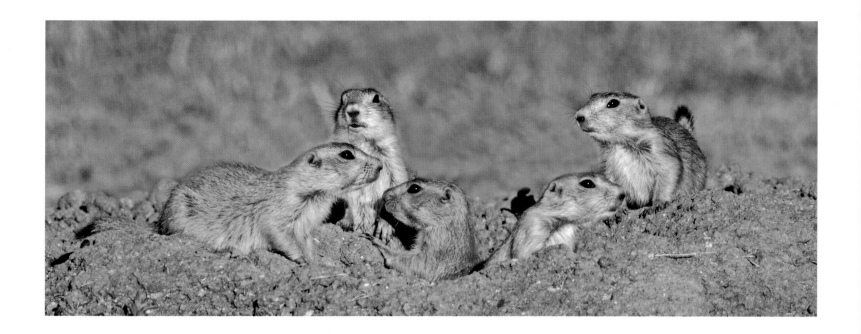

When they did, the pups huddled tight when they saw a group of mammals surface from a nearby burrow.

"Those are prairie dogs," explained Mom. "They are probably the most important animals here. We use their tunnel systems for our homes, along with mice, ferrets, and others, and they are delicious to eat."

"Can we catch one?" asked Ethan, as Jacob playfully tugged at his brother's ear.

"It's not that easy," said Dad. "They have guards near the exits and escape routes below. Plus, they're bigger than you are right now. But next year, when you're adults, you'll weigh more than five pounds, nearly double their size."

"So can we eat one next year?" Jacob asked.

"If you listen this year," replied Mom.

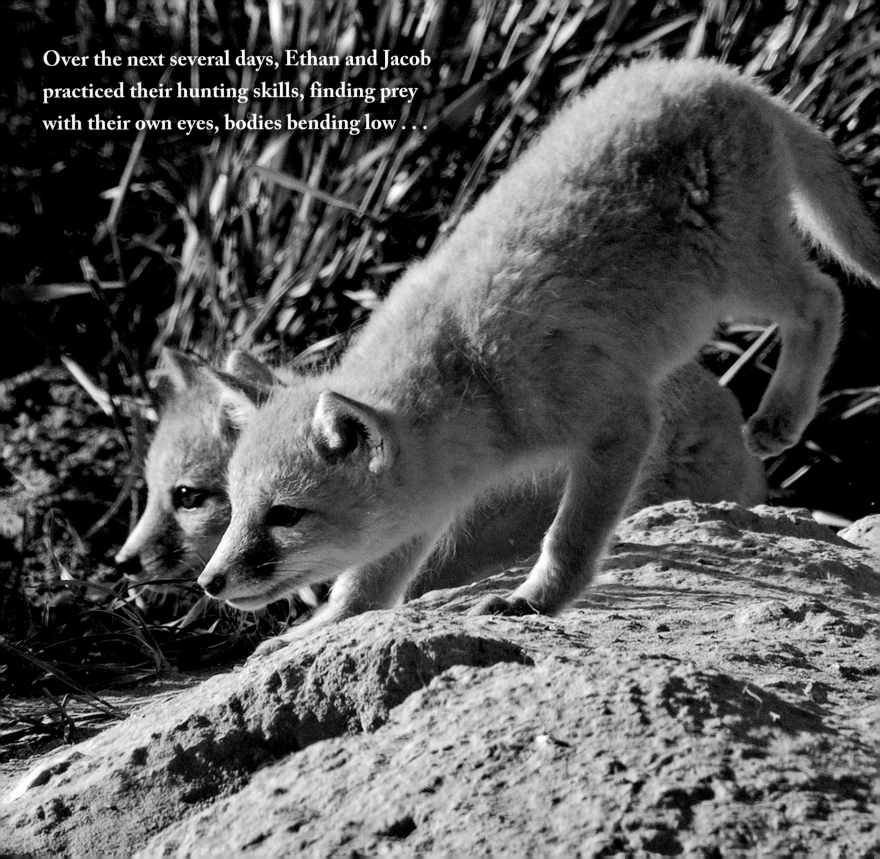

Over the next several days, Ethan and Jacob practiced their hunting skills, finding prey with their own eyes, bodies bending low . . .

. . . and attacking with their claws and mouths, while
Mom or Dad always guarded nearby.

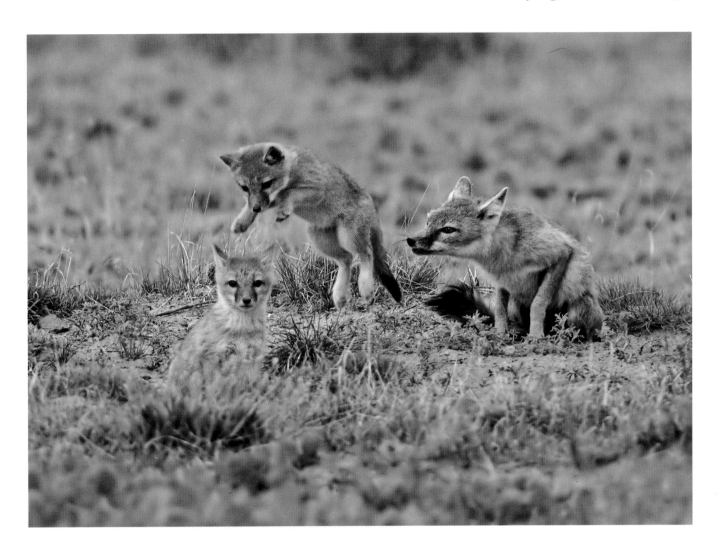

That is, until one day when the pups were left alone so
Mom and Dad could hunt more efficiently for the family.

Immediately, Jacob knew exactly what to do: start a game of chase! Nearby, a red-tailed hawk watched the pups and plotted her descent.

"Brother, we should be watching for predators," suggested Ethan, stopping the game.

"We'll be fine," responded Jacob, this time nibbling at one of his brother's legs.

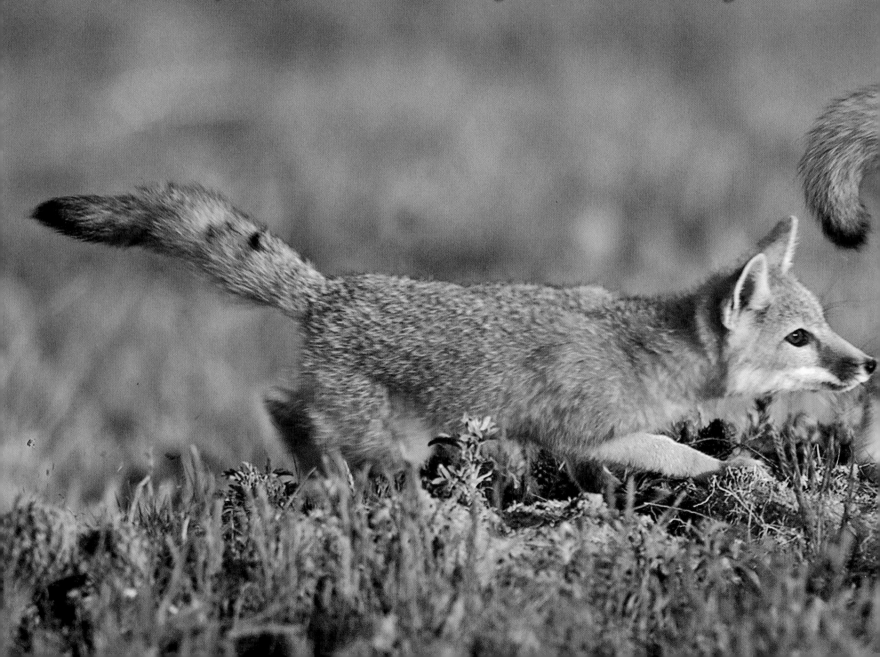

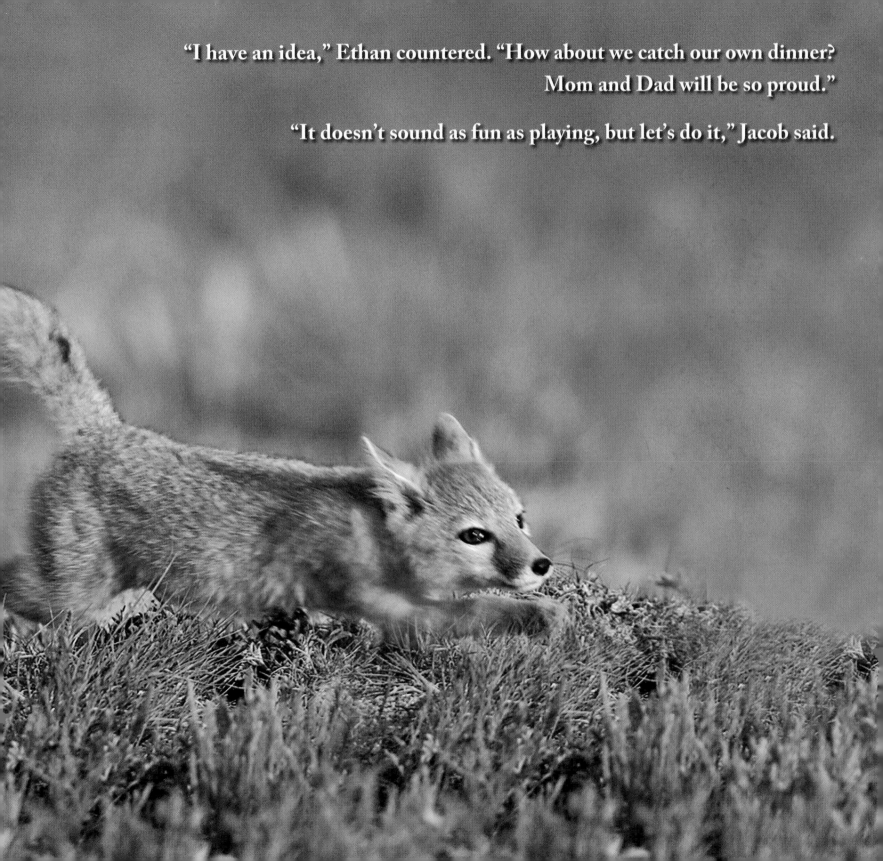

"I have an idea," Ethan countered. "How about we catch our own dinner? Mom and Dad will be so proud."

"It doesn't sound as fun as playing, but let's do it," Jacob said.

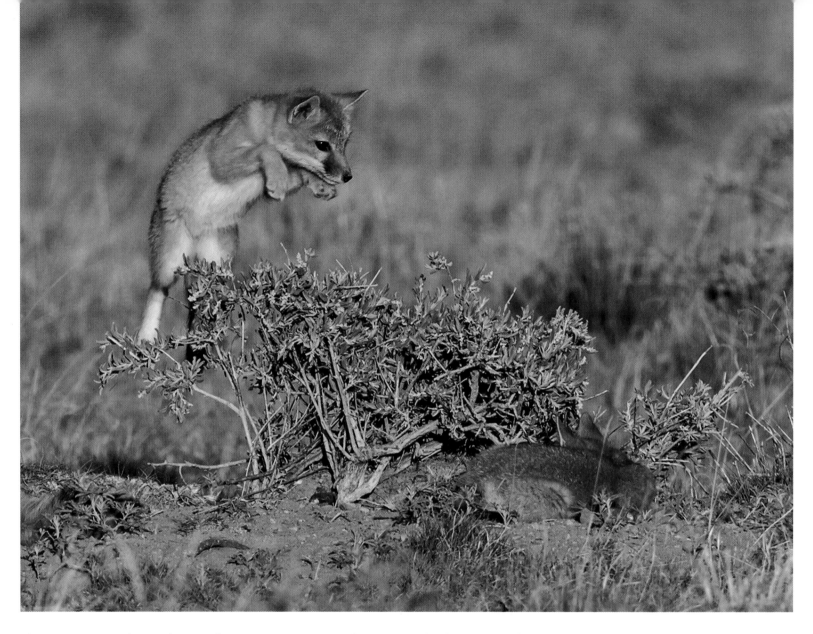

As soon as their hunt began, a ground squirrel shot out from a bush and the brothers pursued it, closing in with each step. When Ethan got within attacking distance, he sprang toward the mammal and they both rolled across the prairie, dust flying in every direction.

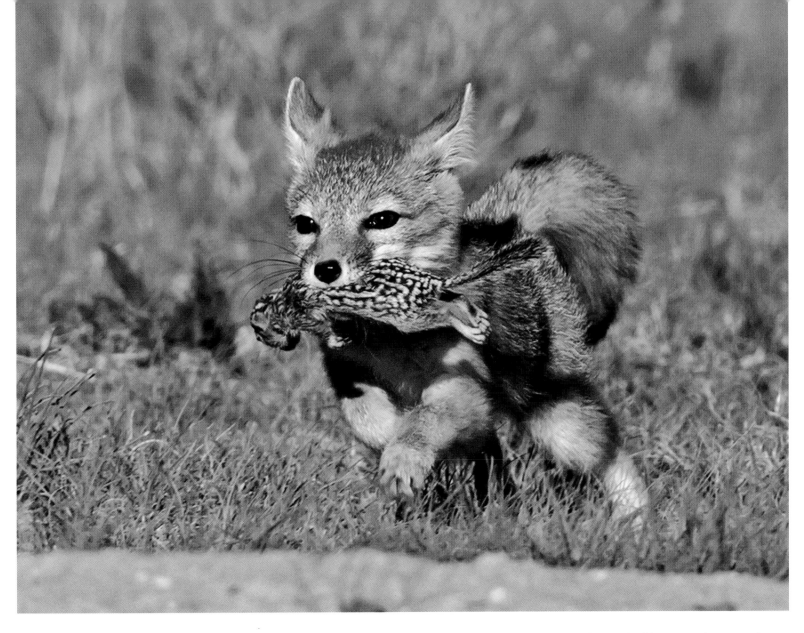

Seconds later, Ethan was running toward their den with his first kill. Jacob, trailing behind, shouted with delight. "You did it, Ethan! You did it!"

Neither of them noticed the quickly approaching raptor.

But a returning Mom and Dad did. "Down!" Dad screamed.

Ethan and Jacob ducked into the closest den as the hawk's talons crashed beside them.

Trembling, the brothers waited until Mom and Dad had crawled inside.

"Are you hurt?" Mom asked.

"No," they answered together.

"Were you watching out?" Dad asked.

"No," Ethan confessed.

"But Ethan did catch a ground squirrel," Jacob boasted, a point neither Mom or Dad wanted to hear at that exact moment.

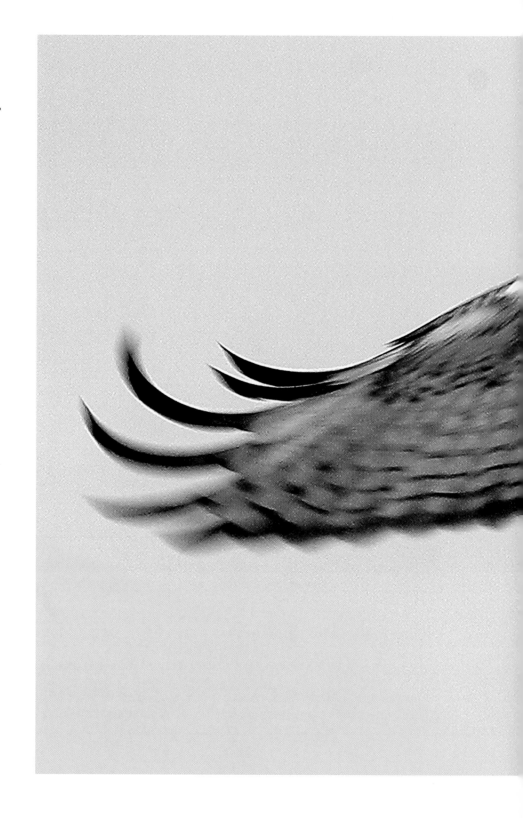

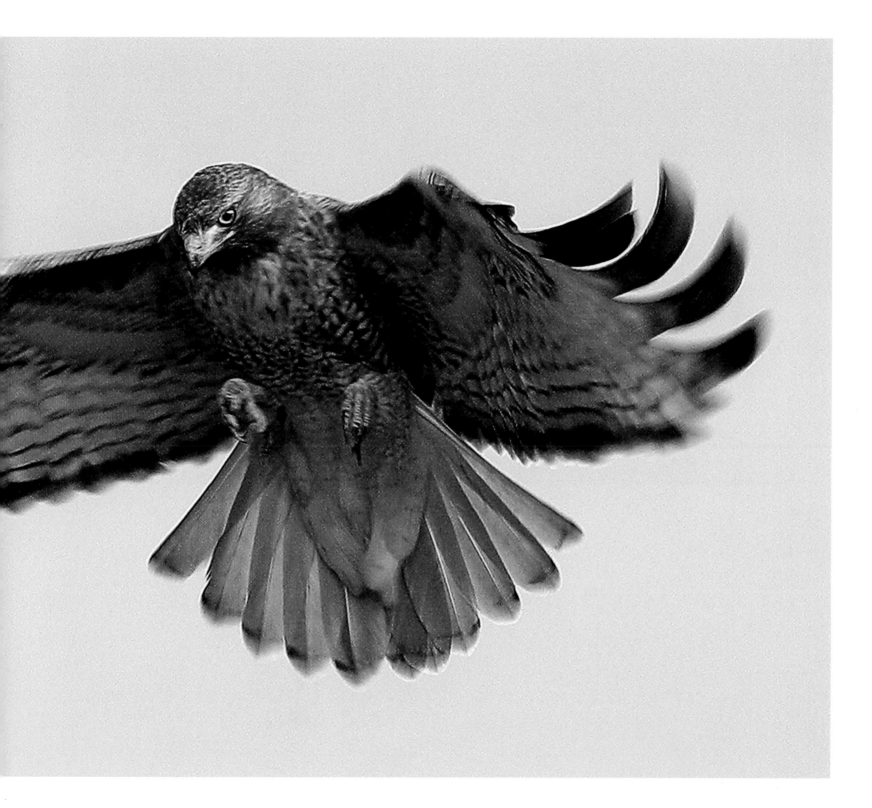

As the spring progressed, Jacob and Ethan came out of their dens near the prairie dog town more often, each day gaining additional confidence.

Both grew strong . . .

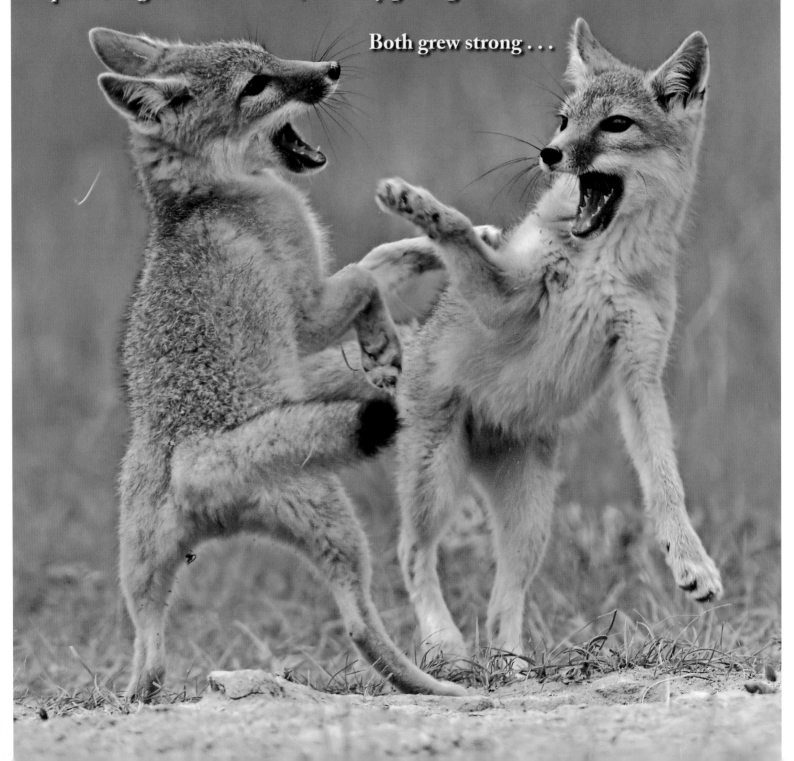

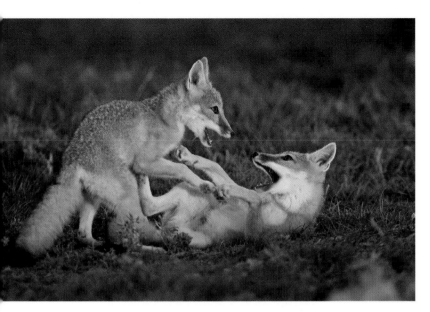

. . . but Ethan grew stronger.

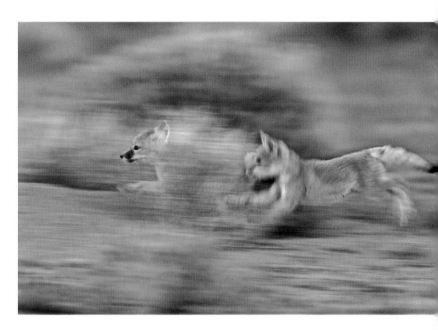

Both ran fast . . .

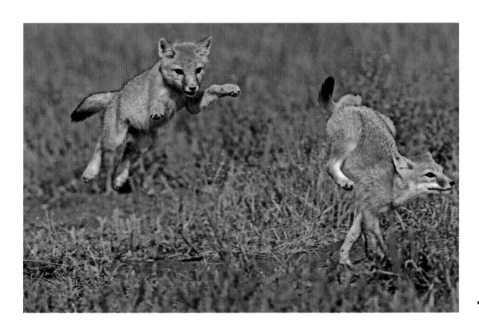

. . . but Ethan ran faster.

And throughout their education, the brothers asked more questions.

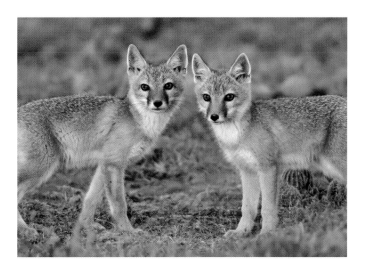

"Are there other places we could live?" wondered Jacob one day.

"Other swifts have told me there are many beautiful places," Dad said. "But we can't see or run well near trees or mountains."

"Should we always run from danger?" asked Ethan another time. "Do we ever fight?"

"Your speed is your greatest gift," answered Mom. "Never forget that."

Days later, after three failed nights of hunting as a family, Mom and Dad had to leave the brothers alone again and go in search of food.

"Take care of your brother," Mom told Ethan, and then she turned to Jacob. "You take care of *your* brother," she repeated to him. "We will be back soon."

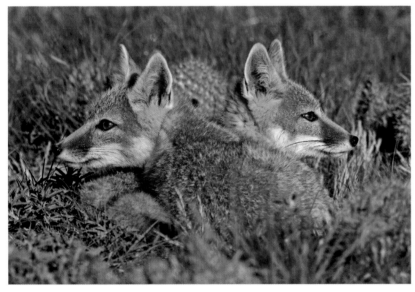

That afternoon, they protected each other for quite some time, but after a while Jacob began to play and lost focus on his surroundings for only a moment.

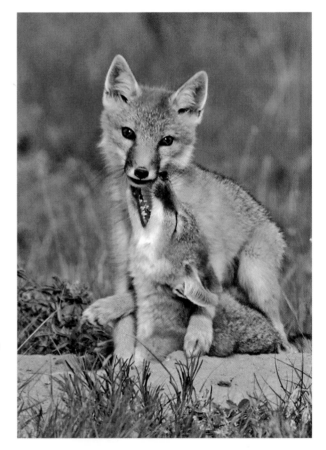

But not Ethan, as he saw the coyote silently approaching.

"Jacob, we have to run," Ethan whispered.

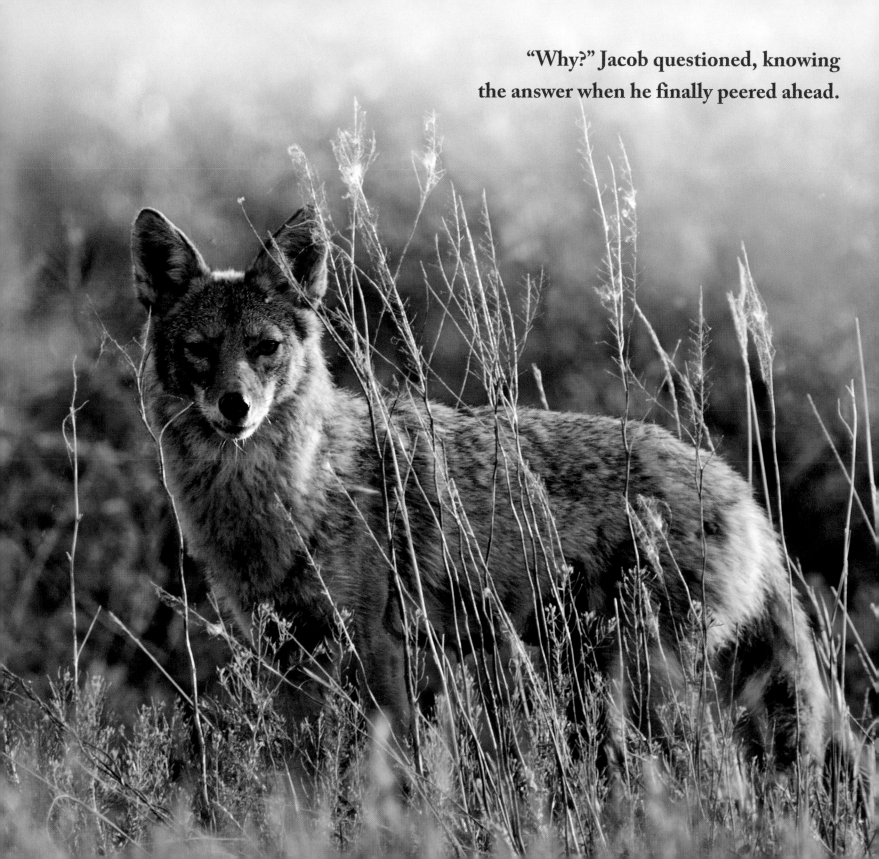

"Why?" Jacob questioned, knowing
the answer when he finally peered ahead.

The brothers separated, their eyes fixed on the coyote. What they failed to notice was the golden eagle flying above.

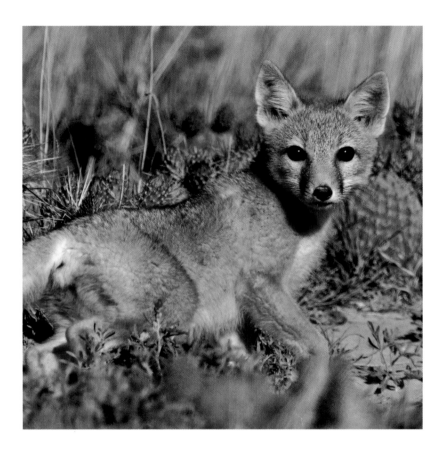

When they finally saw the eagle, they scattered frantically – Jacob into their family den and Ethan toward another burrow he would never reach. Moments later, following a flurry of wings, feathers, and talons, Ethan was gone.

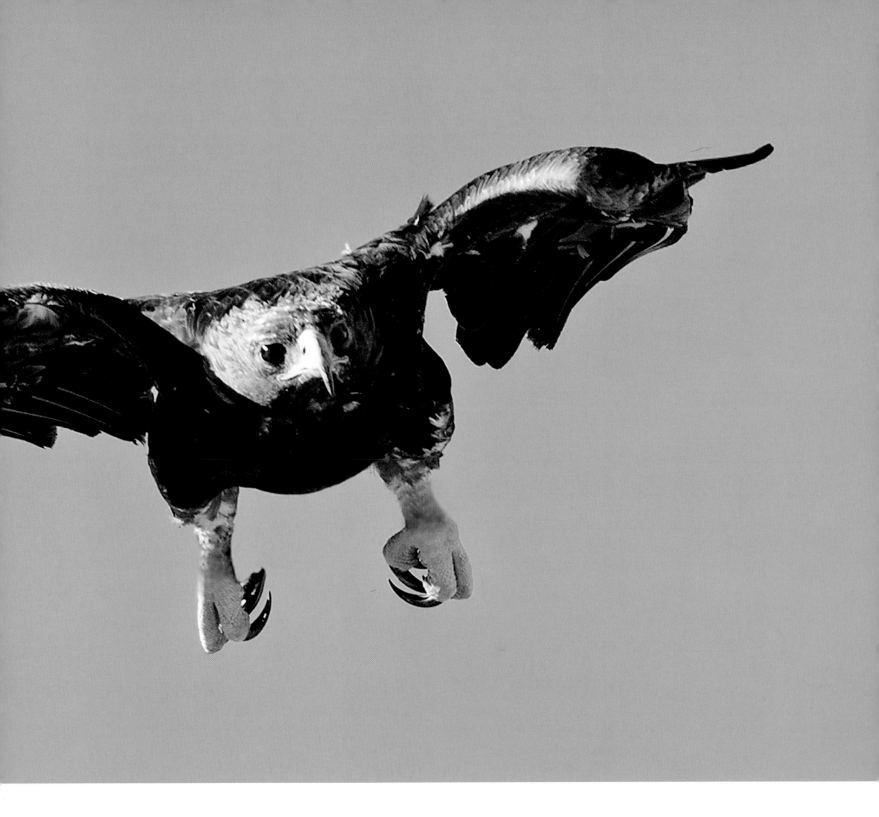

When Mom and Dad reentered the den, they found Jacob alone.

"Where is Ethan?" Mom shrieked.

"I don't know," Jacob whimpered.

"I will find him," Dad growled, sprinting into the last light of day.

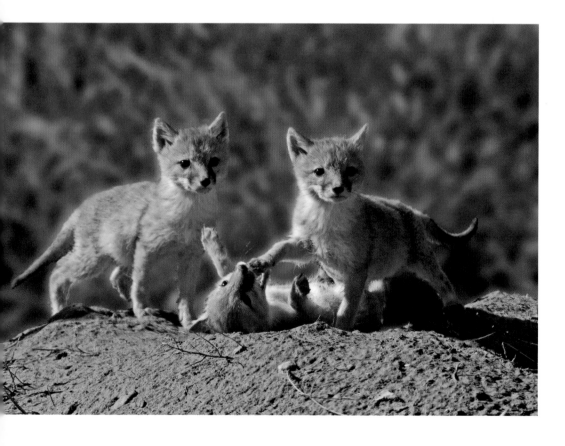

While Mom knew Dad would search all night for their son, she also already suspected Ethan was gone forever. *We're going to lose them all again – just like last year*, she thought, as the darkness from the burrow surrounded the only little pup she had left.

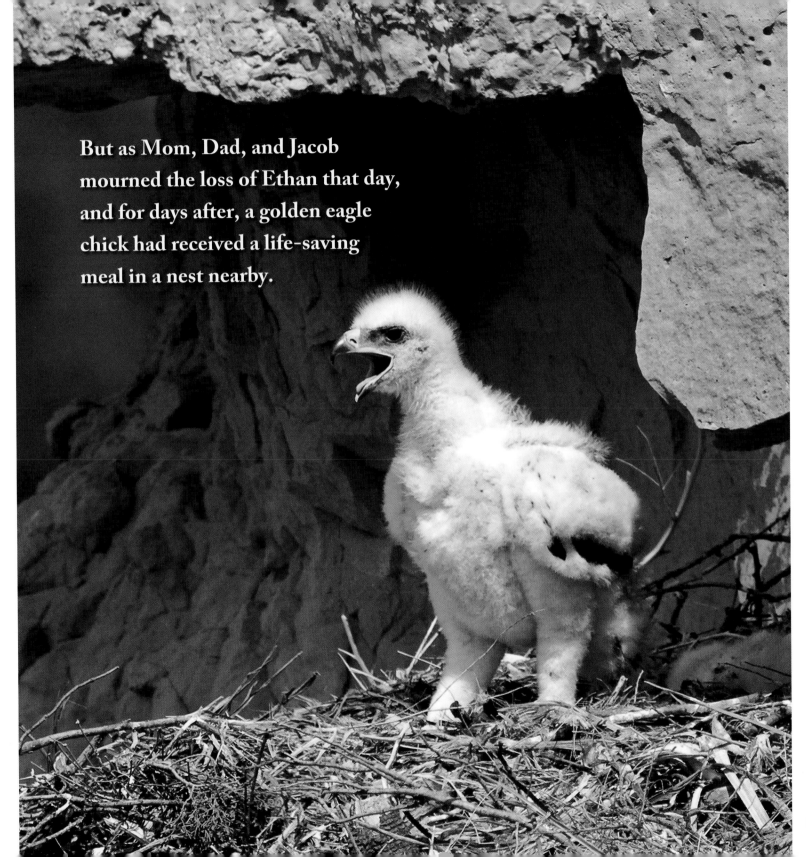

But as Mom, Dad, and Jacob
mourned the loss of Ethan that day,
and for days after, a golden eagle
chick had received a life-saving
meal in a nest nearby.

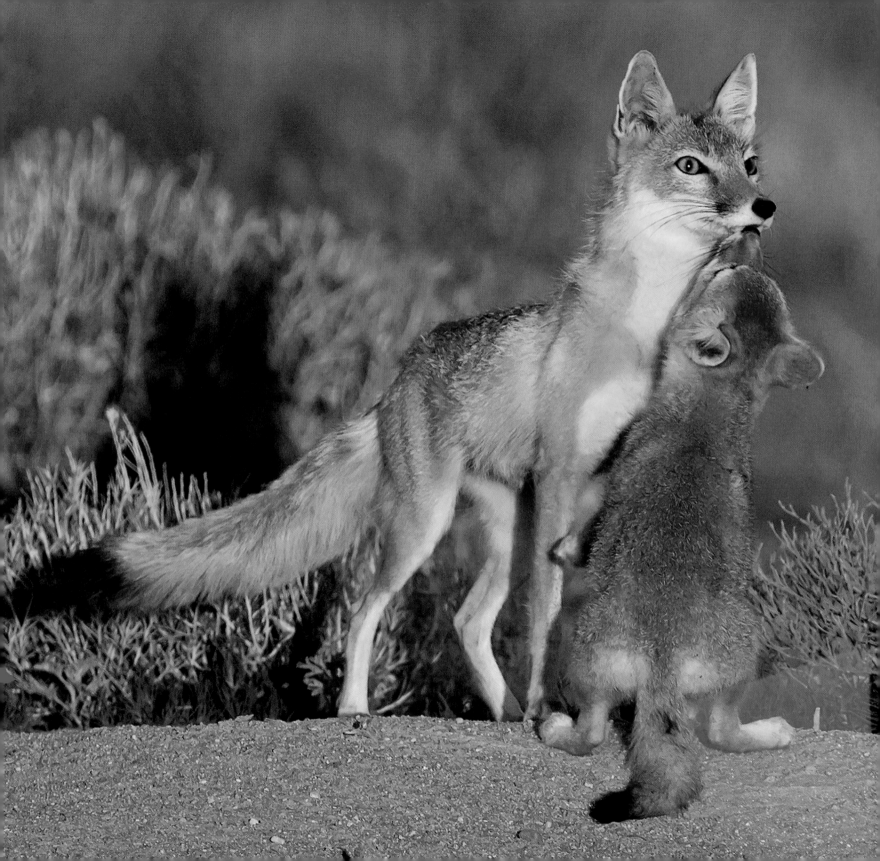

Jacob remained underground for many days and nights as Mom or Dad guarded him. Then, way before she was ready and still fearful of what lurked above, Mom led Jacob back to the daylight. Immediately, he began nuzzling his face against hers. As much as she wanted this moment to last forever, her memories of Ethan wouldn't allow it.

How could the strongest and fastest be gone first? she thought. *How long will Jacob last?*

"Are you watching?" she said aloud.

"You're watching for me," answered Jacob.

"Then you still haven't learned yet," reacted Mom. "Ethan's not here to protect you anymore."

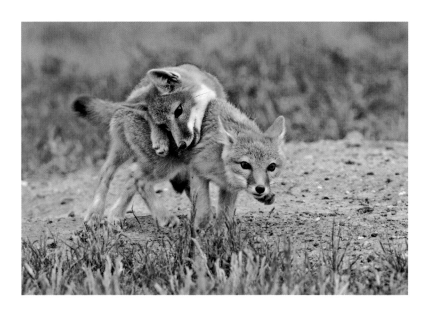

For the next several days, Mom's words haunted Jacob and spurred him into action. He first recalled the wrestling matches with his brother, but then also remembered Ethan's ability to focus.

Then he thought about their hunts together, and he recalled Ethan's concentration.

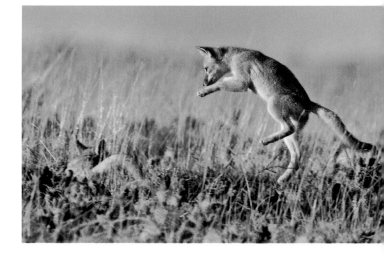

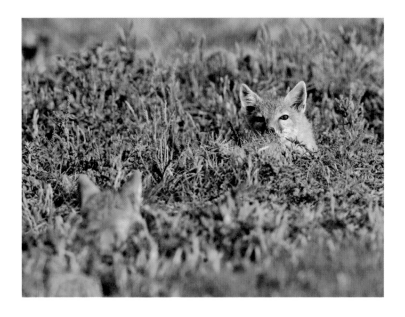

Slowly, Jacob began to combine what he had learned from his parents and his big brother – and he began to thrive.

"Hunt lower and quieter," Dad demonstrated, "just like this."

"Yes, Dad."

"What foods do we eat?" asked Mom another day.

"Rabbits, mice, birds, reptiles," answered Jacob. "Anything we can find. Even berries and seeds."

He was paying attention to every lesson now, hunting with purpose and bringing back his own food to their dens. Even when Jacob encountered other swifts his age, they couldn't compete with his growing speed or hunting ability.

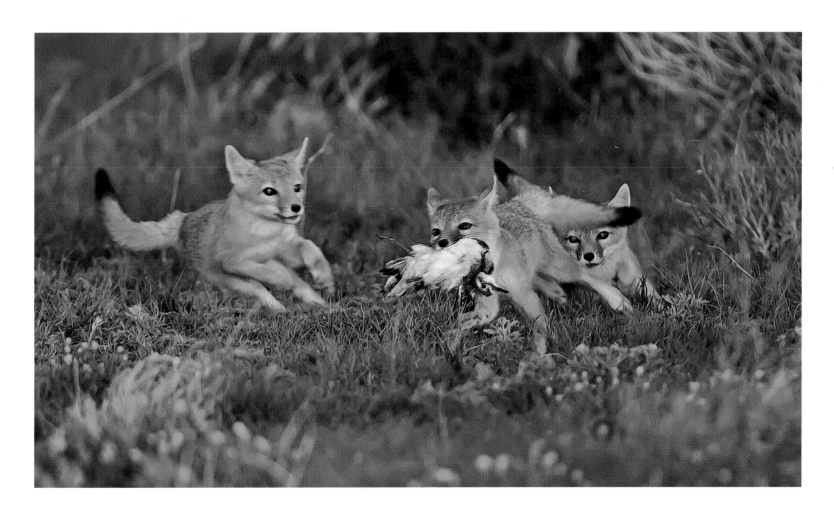

He prospered so well that one day, as the cooler winds of autumn took hold, he made an announcement. "I'm ready to be on my own."

"Why do you think you're ready to leave?" quizzed Mom.

"Because I'm the largest and strongest fox here."

"No," she replied, "red foxes are the strongest. They're twice as big as you and clever hunters."

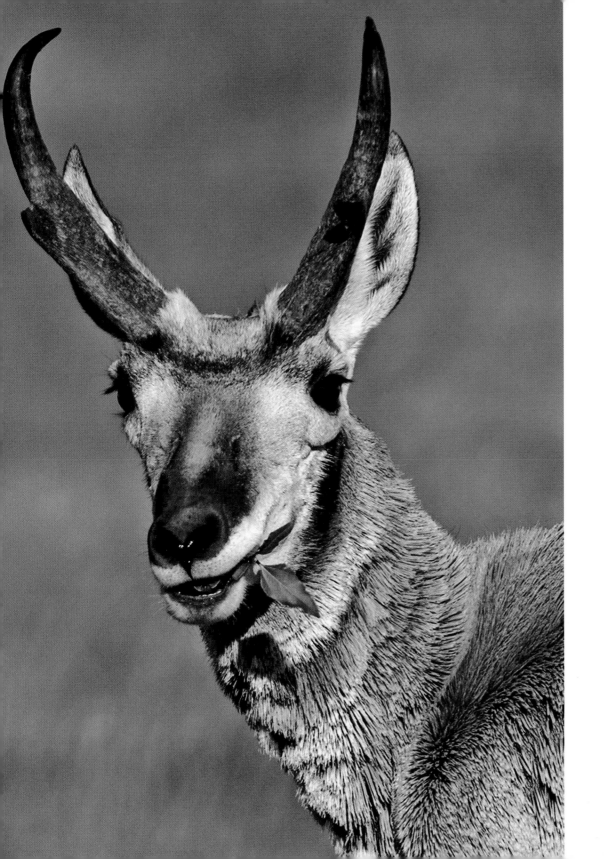

"Okay," Jacob said. "Now I'm ready."

"And why is that?"

"Because I'm the fastest animal here," Jacob bragged.

"No," corrected Mom. "Pronghorns are the fastest."

"What's a pronghorn?"

Jacob learned that pronghorns ate grass, but he had to be careful when near them because both males and females had horns they would use to protect their young.

"Uh, how about I leave tomorrow, Mom?" the reluctant pup asked.

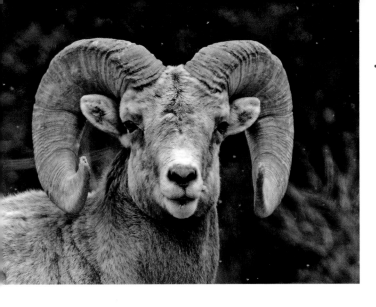

Jacob repeated his departure plans for several days, only to be delayed by Mom each time.

She taught him about the horn-crashing fights of bighorn sheep . . .

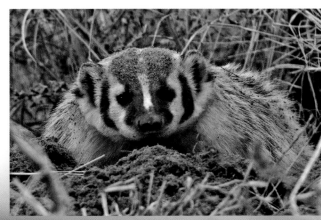

. . . the ferocity of badgers . . .

. . . and the prairie-changing practices of humans.

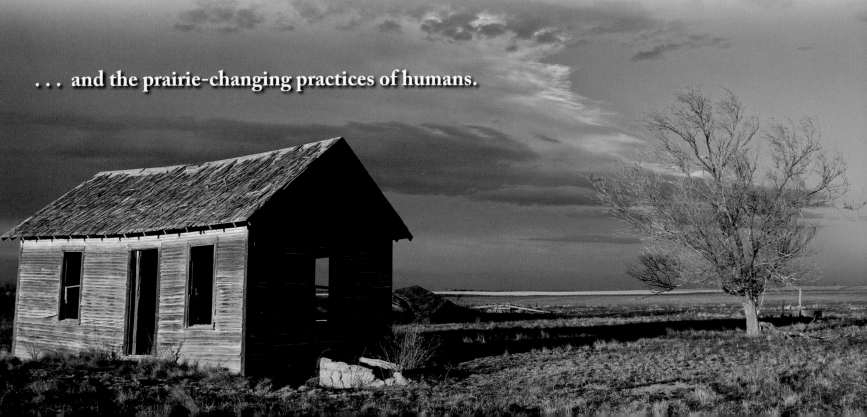

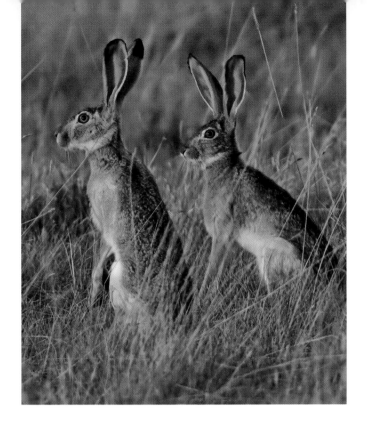

On one particular afternoon, as Jacob eyed a pair of jackrabbits living free on the prairie, he decided his own freedom needed to come that night.

When he told Mom, she was once again ready with another lesson. "What do you know about rattlesnakes?" she asked.

What she wasn't ready for was his answer.

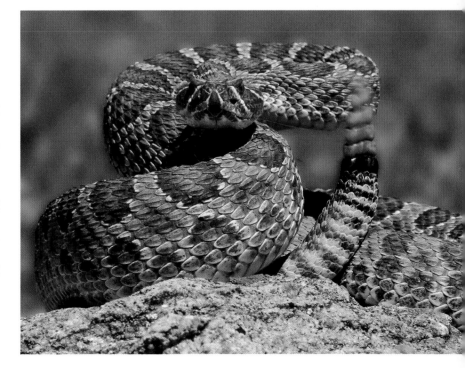

"Not much," he said. "But I'll be careful, Mom. You and Dad have taught me that this empty place is full of life, but there's no way you can show me everything. Some things I must learn on my own."

The den went silent.

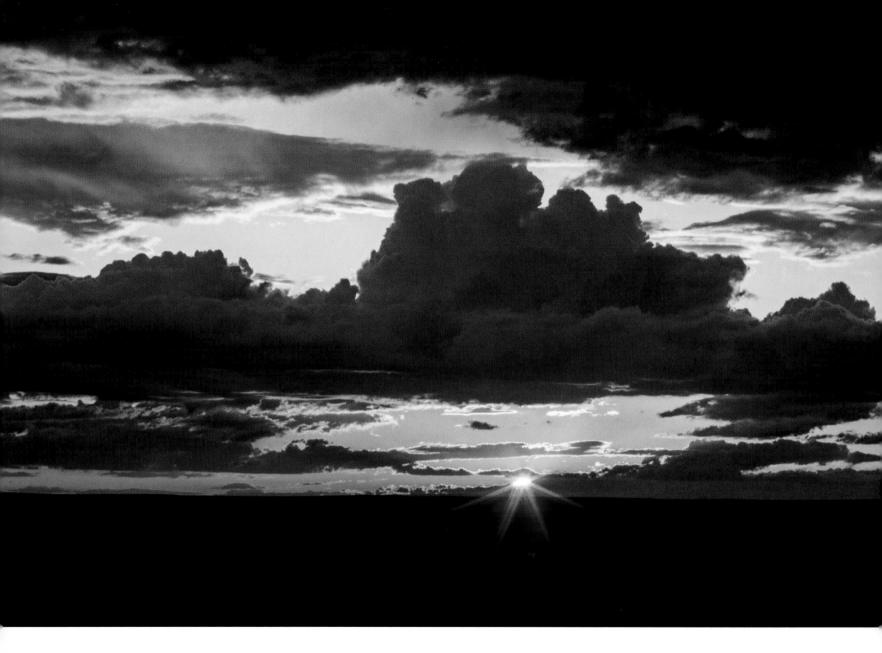

"I'll be right back," Jacob added, emerging into the cloud-filled dusk. When he saw the sun setting, the western sky was so dark, yet so colorful, he wanted to touch it.

He moved slowly at first, but as the last shadows of the day lengthened, Jacob began to run, the wind pushing so freely through his fur that he thought he could go on forever.

Moments later, Mom called out. "Jacob," she said. "Jacob." Then to Dad: "Have you seen Jacob?"

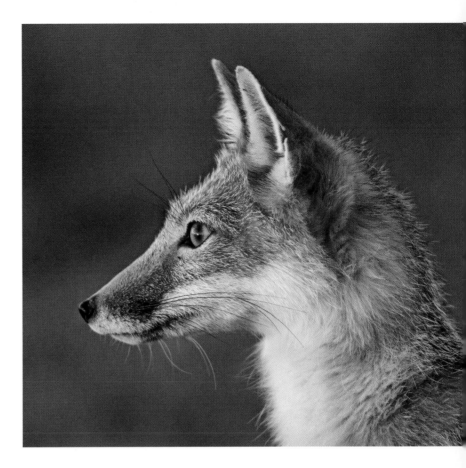

"No," he replied.

Jacob was gone.

"You think he knows how much we love him?" Mom asked.

"Not yet," replied Dad. "But he will next spring, when he has his own pups."

"Pups," Mom repeated, knowing her own stomach would soon be growing, as they went below for their first good nap in a very long time.

Yet before Mom could fall asleep, she remembered when Jacob and Ethan were young and could still feel their little paws all around her.

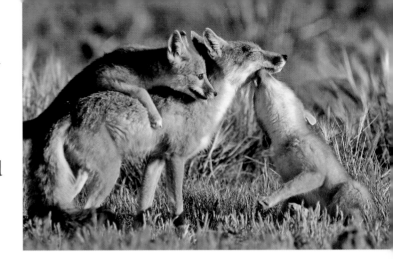

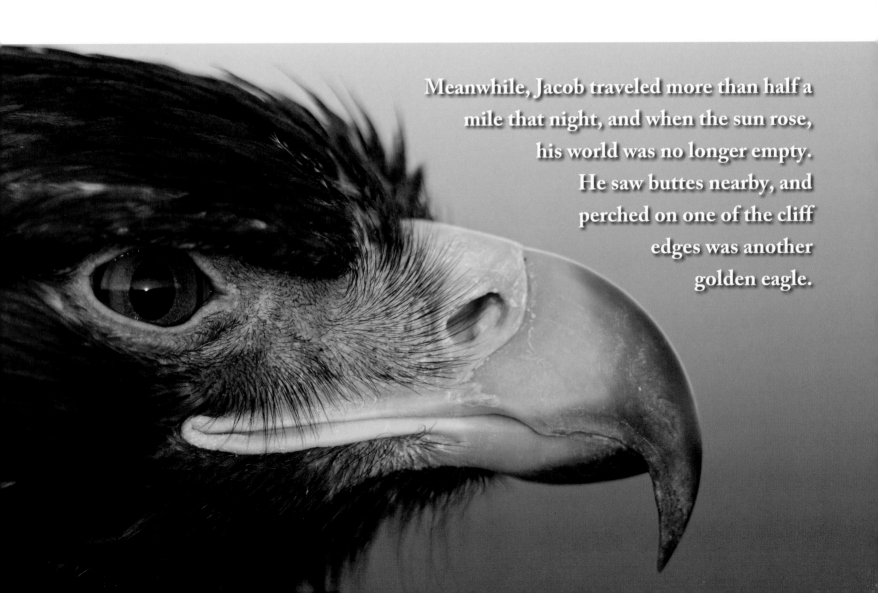

Meanwhile, Jacob traveled more than half a mile that night, and when the sun rose, his world was no longer empty. He saw buttes nearby, and perched on one of the cliff edges was another golden eagle.

Jacob looked for a place to hide as the eagle lifted and flew toward him.

Unable to find a den, Jacob lowered his body; his ears were the only things visible.

It will not work, Dad would have said. *You have to find shelter*. So Jacob ran. Fast.

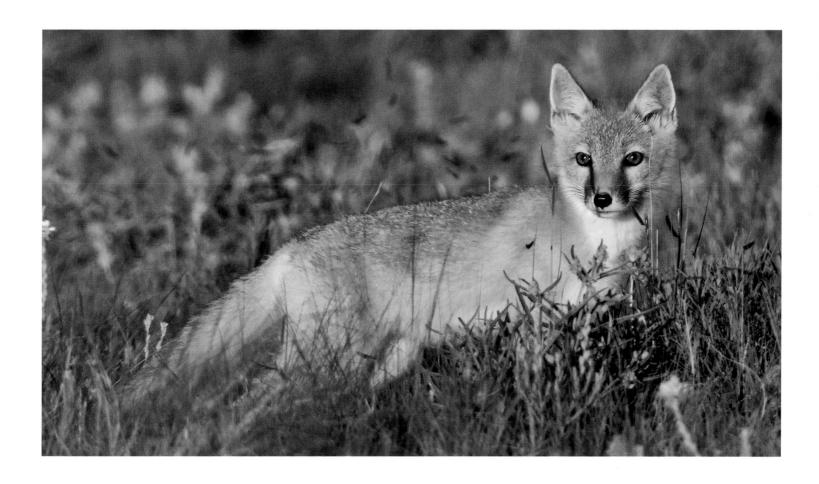

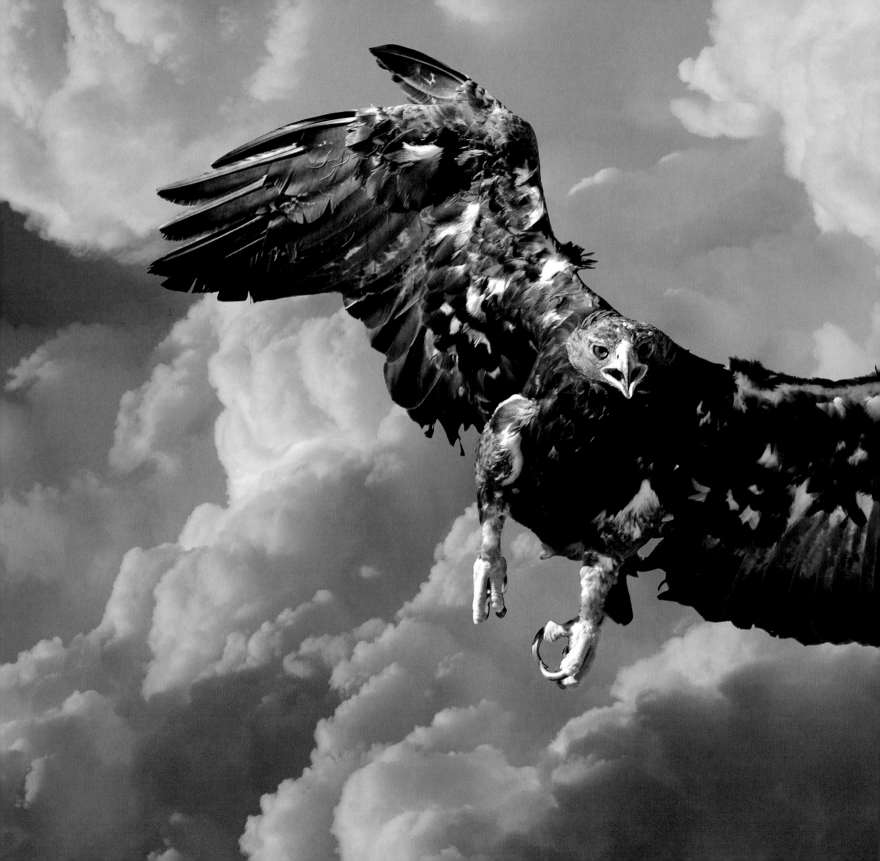

As the eagle bore down, the sky blackening, Jacob saw a hole. A wonderful hole!

There is more than prairie dogs in those holes, Mom would have said.

He had no other options. Whatever lived in that tunnel was better than what was flying toward him from above. Jacob began to snarl as he neared, his teeth and claws appearing.

Then he dove in as the *swoosh* from the eagle's wings faded in the distance.

With his heart still racing, Jacob waited. Then he realized something. He wasn't alone.

"Ethan?" he said.

"No, my name is Violet," the other swift fox said. "Who's Ethan?"

Jacob answered Violet's question and many more that day, as she shared stories about her own family. She had lost two brothers, one on the highway and another shortly after birth. But she also had a sister, Lily, who had left the family just four days before Violet.

"Do you miss them?" Jacob asked.

"When I think about it, yes. But not often. I have to stay focused."

"Like Ethan," Jacob remembered aloud.

"Yes," Violet replied, "but better."

Before long, rain began to fall. They curled up beneath the ground until the entire world quieted.

When they emerged, their eyes both locked on the rainbow.

"A new life has begun," said Violet.

"Your mom must have told you that, too," said Jacob. "I wonder whose?"

But they both already knew the answer.

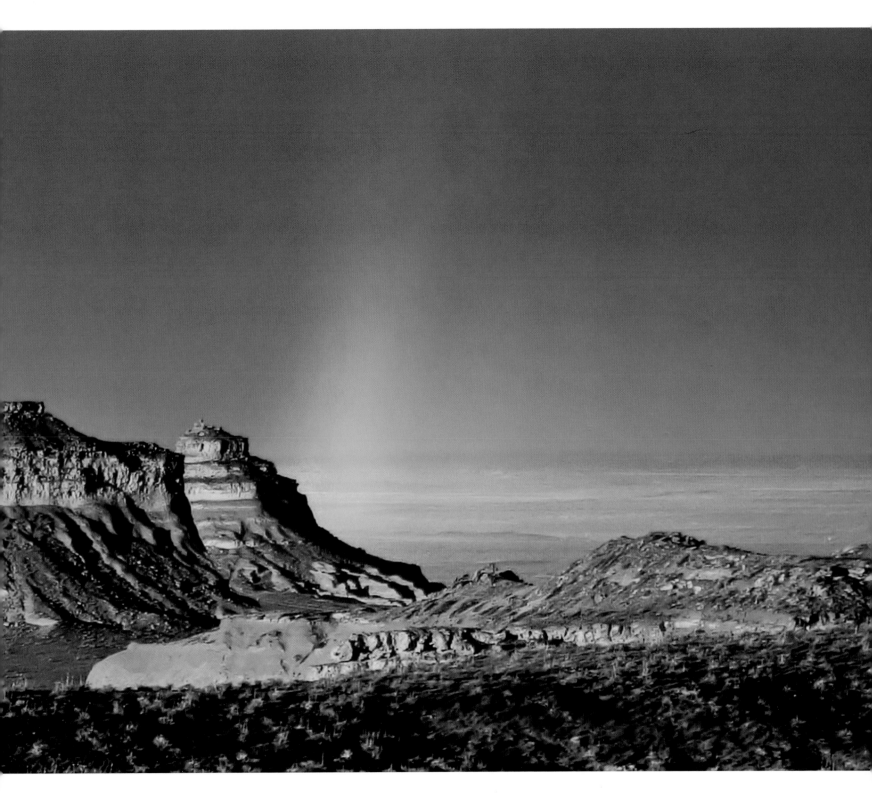

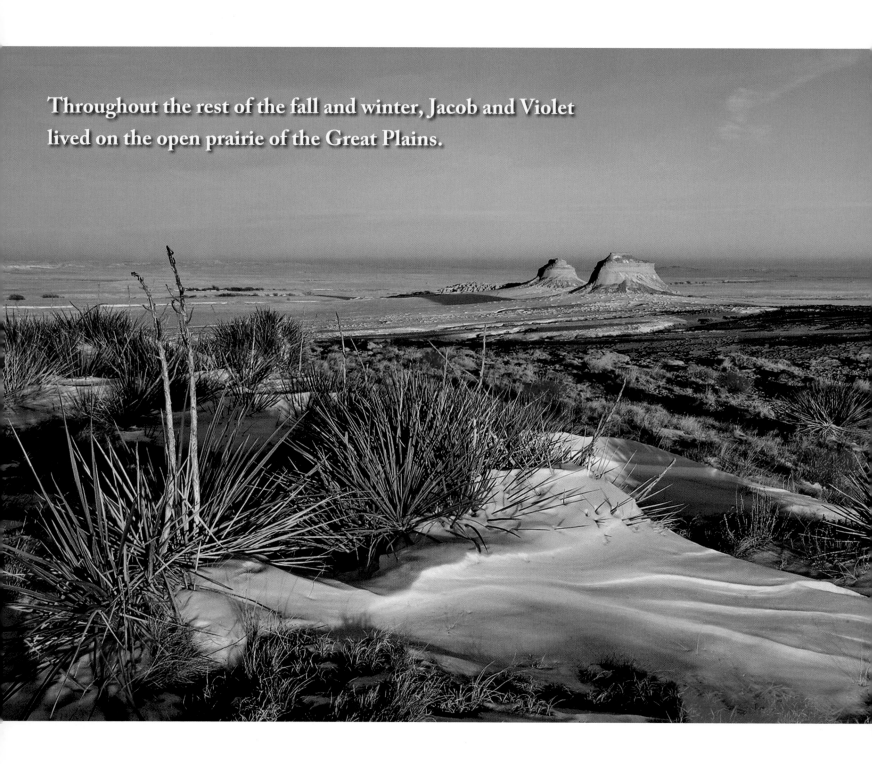

Throughout the rest of the fall and winter, Jacob and Violet
lived on the open prairie of the Great Plains.

They saw many animals, including more than one prairie dog they wanted to eat . . .

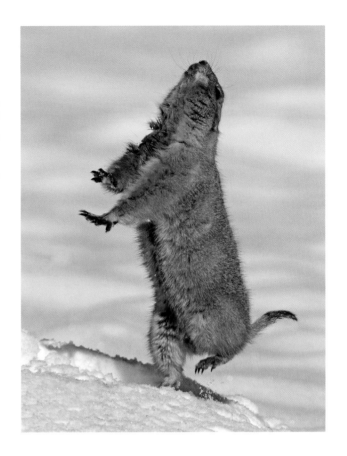

. . . and at least one bald eagle that wanted to eat them.

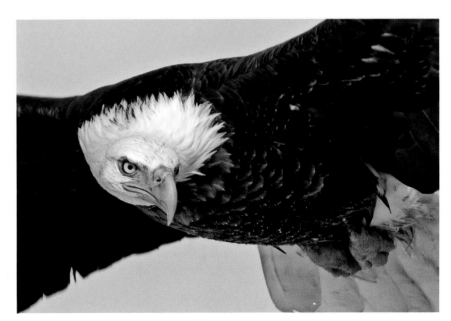

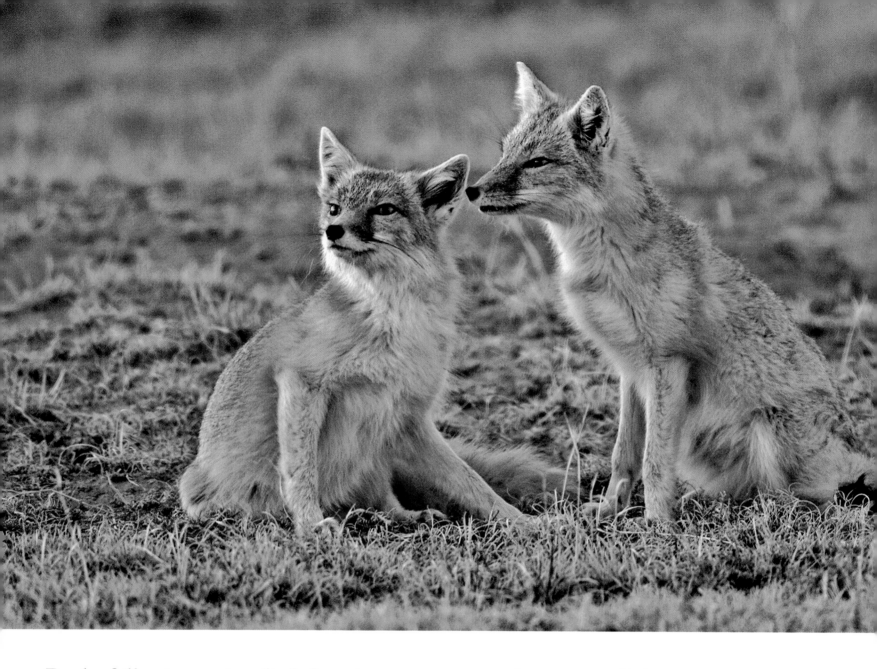

By the following spring, little hearts were once again beating in all directions on the shortgrass prairie, including hearts in Jacob and Violet's own den. With a litter of their own pups – Abel, Ava, Eli, and, of course, Ethan – the two new parents began to teach everything they had learned from their own families.

Then, once the pups were aboveground, Jacob and Violet began their first sunlit lesson.

"This is how you watch the sky," instructed Jacob.

"This is how you watch the land," taught Violet.

Over the coming days, each of the pups continued to learn, yet little Ethan would respond the same after each teaching: "That's great," he would say, "but who wants to play?"

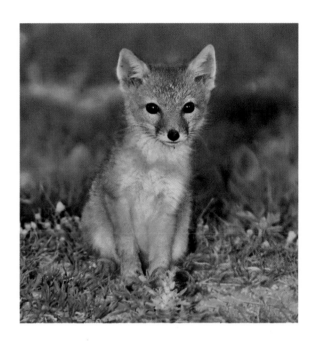

"I love you too much to play right now," Violet would respond.

"As do I," Jacob would add, constantly peering in every direction of their beautiful shortgrass home.

Afterword

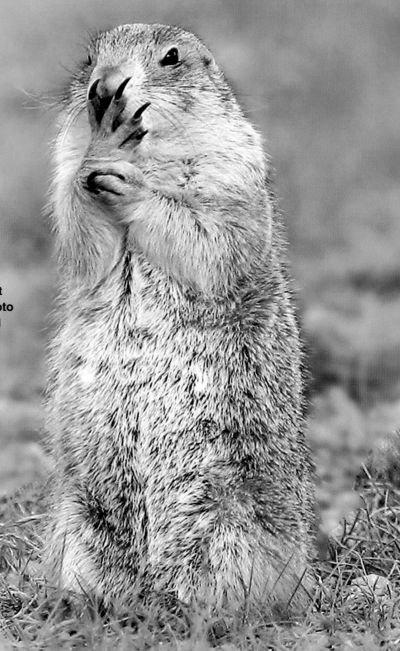

I made a mistake in the early drafts of what eventually became *The Tale of Jacob Swift*. I had tried to write to a set of photos I already had in hand, breaking my No. 1 rule about writing photo fiction: the story comes first. The photos, while often drawing the most attention, are the icing on the cake for a book such as this, and they provide a complement to a story that is compelling in its simplest form of black ink on white paper.

After struggling with the story for more than a year, I started over, creating a storyboard for *Jacob Swift* in an effort to identify every scene I thought the story needed, scribbling on sticky notes and taping them to a poster board. The result: a clean draft in less than two days. A week later I contacted Rob Palmer, whose images I had first seen online. I had been immediately mesmerized, and started plugging his photographs into the story. Then came the review process.

While I was fortunate to receive the assistance of 20 Gretna Elementary School fourth-graders during the revision phase of my first book, *Have You Seen Mary?*, I wanted to receive even more opinions about *Jacob Swift*. I conferred with instructional facilitator Dawn Spurck, who worked with the Papillion–La Vista Schools Foundation in Nebraska to arrange for me a series of peer review sessions with more than a thousand fourth-graders in their district over the course of a three-week span. During these individual class sessions the students critiqued a number of facets of the story including, but not limited to, plot and character development, repetition, clarity, word choice, and even photo selections. "Mr. Jeff, can you please eliminate the filler," one student told me, which was a very nice way of saying that certain parts of the story were rambling uncontrollably. After visiting 14 elementary schools I had rewritten the story 17 more times. Their critiques were invaluable.

Then I contacted colleague T. J. Fontaine, a professor at the University of Nebraska, and asked if he knew a swift fox expert who could help with the book's biological information. This is how Dr. Teresa Frink came on board to write the foreword, which helps relate the fictional parts with the realities regarding this at-risk species.

Designer Tim Reigert's layout came next, as he brought the photographs to life on the page. Then the adult peer reviewing began, including Mom, Dad, Amy, Ann, Chris, Claire, Jenny, Jess, Justin, Kristal, Margie, Peg, Rob, Sarah, my 5-year-old daughter, Madeline, and my wife, Laura. Listening to these varying voices – from editors and colleagues to lifelong friends – led me to make further changes to *Jacob Swift* with the purpose of entertaining and educating readers of all ages about this seldom-seen grassland mammal.

My thanks to them all.

— Jeff Kurrus, July 22, 2014